GANYMED

Printing · Publishing · Design

Victoria and Albert Museum
19 November 1980 – 31 January 1981

Cover

Henry Moore
"The Reclining Figure", plate 1.
Etching and aquatint. 1978

Published by the Victoria and Albert Museum
Designed and printed by Harrison & Sons (London) Limited
ISBN 0 905209 14 1

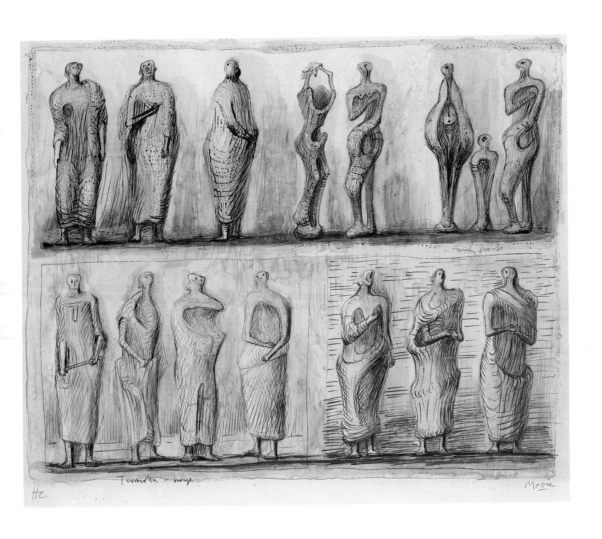

Henry Moore
"Standing Figures".
Collograph. 1951

Preface

A small firm like Ganymed undoubtedly
would not have been able to have kept
going as long as it did without the personal
contacts forged and maintained by its
Board of Directors. Bernhard Baer has
been a Director since March 1950 and very
kindly agreed to write the Introduction to
this catalogue. His enthusiasm and
dedication is clear both from the way he
writes and from the exacting standards that
Ganymed achieved over the years. We are
particularly grateful to him and his wife
Ann, also a Director of Ganymed, for this
Introduction and for the considerable help
and advice they have both given with the
exhibition. We are also indebted to all
those who loaned objects, including the
Moore Foundation (numbers 31 and 32)
and the Department of Prints and
Drawings. Lastly we are grateful for
permission to reproduce the illustrations
contained in this catalogue.

Duncan Haldane
Deputy Keeper of the Library

Introduction

Ganymed Press London, which was founded in 1947, had its origins in Ganymed Graphische Anstalt of Berlin. This was a firm of collotype printers founded by Bruno Deja, a printer, and the art historian Julius Meier-Graefe. Meier-Graefe had been the editor of "Pan" in the early years of this century, had written books on modern art, had introduced French painting to the German public, and was in his influence comparable with Roger Fry in this country. He was the inspired director of the Marées Gesellschaft which published portfolios of fascimiles of drawings and water colours from Dürer to Cézanne and Van Gogh and to modern German artists. These facsimiles were at first produced by various collotype printers in Germany, but Meier-Graefe felt he needed his own printing firm, devoted only to the highest level of work, where he could be sure of obtaining the quality he desired. He persuaded Bruno Deja, an outstanding expert in this field, to set up such a printing works. It was Meier-Graefe who gave this new firm its name "Ganymed"; a drawing of Ganymede and the eagle by Hans von Marées, an artist he loved, came to his mind when the naming of the new firm was discussed. In the years that followed the first world war, years in Berlin riddled with hunger, revolution, street-fighting and roaring inflation, Ganymed printed and the Marées Society published portfolios of facsimiles of a quality not seen before.

During the second world war the Ganymed printing works were bombed, the store of negatives destroyed, the presses buried under heaps of rubble, the trained workers dispersed, but Bruno Deja survived. Meier-Graefe had died before the outbreak of the war, mercifully for him, as his whole world had been shattered by the Third Reich.

It was just after the end of the second world war that two young British soldiers in the army of occupation in Berlin encountered Bruno Deja and knowing of the fame of his firm recognised the importance of the man. He told them of his hopes of rebuilding his firm in Berlin and of his willingness to assist in the founding of a similar kind of printing works in England. The two soldiers, demobilised and back in civilian London life, reported this encounter to the directors of Lund Humphries, Eric Humphries and E. C. Gregory and found a sympathetic response. Eric Humphries with his ideals of the highest quality in printing and E. C. Gregory, the friend of Herbert Read, the early patron of Henry Moore, Ben Nicholson, Barbara Hepworth and a supporter of modern design, were both eager to achieve in this country what had previously been done by Ganymed in Berlin. They were joined by The New Statesman, each with a half share, and went to Berlin to meet Bruno Deja. They bought some of his damaged presses, which had to be dug from the rubble, assisted him in re-establishing his own printing works and paid him for guidance and instruction in the setting up of a collotype workshop in England. Deja supplied an experienced printer and a

retoucher who had both been trained in his methods. When Lund Humphries and The New Statesman founded their new firm in England Bruno Deja gave them permission to use the name Ganymed. There was, however, no business link between Ganymed Press in London and the one which survived in Berlin.

Ganymed Press started working in 1949 and published its first catalogue in the following year. All the subjects announced in it were facsimile reproductions of drawings and watercolours partly selected by The Tate Gallery from their own collection, partly by Lund Humphries and partly by the British Council. It contained among others, works by Blake, Samuel Palmer, Girtin, Cotman, Henry Moore (three subjects), Giacometti, Cézanne and Picasso.

Ganymed Press could well claim to have reached the highest level of facsimile reproduction within the first year of fully working. There had been many teething troubles; the repair of the presses from the ruins of the Berlin establishment, the equipment of the workrooms, the frequent electricity cuts and lowering of the voltage which continued on and off for many years, but most of all the difficulty of finding and training suitable staff for this most exacting of printing processes.

The collotype process of printing is a typical development of the mid-nineteenth century, requiring a combination of machine-power, chemistry and the highest skill from the operators. It had been invented in its outline by Poitevin who described it in 1855 and took out an English patent in the same year. The process could then print only line or flat areas, but not half-tones. It was improved by Josef Albert in 1868 which made it possible to print with a full gradation of tones and it was then taken up by lithographic printers who could reproduce photographs and were no longer limited to the hand-drawn images on the stone. These were the humble beginnings of collotype. Before the end of the century the process was used for the monochrome illustrations of books on art. Botticelli's illustrations of the '*Divina Commedia*' were published by the director of the print room of the Berlin Museum in 1896, reproduced by the collotype department of the Reichsdruckerei. The use of colour had to wait for the next century.

On the technical side the great virtue of collotype is its faithfulness to the finest details and the gradation of the photographic negative. This is due to the absence of a screen, and to the fact that the collotype plate is coated with a continuous tone photographic emulsion. The other important ingredient of the success of the process in reproducing works of art is due to the usual small scale of the enterprise. The atmosphere in a collotype works is more that of a studio than a factory. The workmen have to be highly trained, attuned to the work in hand, meticulous, patient and persevering and the management must keep the ideals of quality and accuracy before them at all times. Most modern developments in the printing industry have bypassed the collotype process. There was no supply

industry which could deliver the printing plates. They have to be coated by hand in the workshop, their life span is short, they cannot be stored for more than a few days. There are no electronic devices which would assist or replace the retouching by hand. The best work can only be achieved by contact with the original — by photographing it under controlled conditions and by adjusting the negatives by careful observation and analysis of the work in hand. All modern printing processes are based on standard methods, which, though there have been great improvements over the last thirty years, basically use four printings with four standard coloured inks. In the ordinary run of commercial work the originals are adjusted to this process. Colour transparencies are used as substitute originals and electronic scanners provide the necessary adjustments for the printing process in hand, leaving little to be done by the retoucher. While these inventions greatly benefited the commercial printer, they did not help the collotype printer confronted with a work of art. One example may suffice: Cézanne's water colour 'Still Life with Chair, Bottle and Apples' contains shades which cannot possibly be re-constituted by the use of standard colour inks or in only four printings. In making this facsimile Ganymed had to print the tone of the aged paper as a single colour but had to omit it from areas where it would degrade the blue. This cobalt blue shade could never be rendered by using the standard cyan blue ink, on the other hand the blue which could emulate the blue in the original could never in combination with yellow yield the vivid green which the artist used in a few small areas. It was, therefore, necessary to print a green from a special plate as the final colour. Altogether it was necessary to build up the reproduction by printing from eight plates, one for the paper tone, one for the grey of the pencil lines, one for the yellow, two for the shades of red, two for the shades of blue and one for the green. The printing of the edition had been preceded by three proofs each requiring the same number of plates. The original water colour had been lent to Ganymed for photography, but a great deal of retouching of the negatives had to be done at the Courtauld Institute, the owners of the original.

Not all reproductions printed by Ganymed were as difficult as this Cézanne but none was easy and each had to be considered as an individual and could not be subjected to standard procedures.

It was always Ganymed's endeavour to reproduce from the original and to have it at the printing works for constant comparison during the process of reproduction. Ganymed will always be indebted to those museums and private collectors who lent valuable paintings and drawings from Rembrandt to Picasso — a co-operation which could not be repeated today.

One factor inherent in the collotype process is the slowness of the printing and the difficulties in controlling the printing plate. Its very virtue of being able to render the finest shades of the original

make it fragile and difficult to control. The printer has to develop the plate on the press and has to control it all the time during the printing run.

Compared to the printer of the standard processes who makes his plate ready and then lets the machine take over, the collotype printer is more like a musician who plays an instrument. He has to mix the ink to the right shade and consistency, put it on the rollers with a palette knife by hand, renewing it throughout the printing run; he has to treat the plate, replenishing its moisture, often only locally by blowing through a tube at an area needing some correction, and he has to inspect each sheet as it comes off the press. He is the true craftsman in the old sense compared with the modern machine minder. Equally skilled is the retoucher, who has to translate the grey gradation of the photographic negative into the colour values and then adjust them as necessary in relation to the original.

When Ganymed Press started there were a number of firms in England printing by collotype. During the 1950's and 1960's all but one ceased to exist. Many of them, printing postcards or illustrations for commercial catalogues ceased because their work had been overtaken by offset, being easier, quicker and cheaper and often better for the purpose. But the existence of these small firms had been a necessary basis for training people some of whom would graduate into the more demanding work of Ganymed.

These are some of the technical odds that Ganymed Press struggled with all the fourteen years of the existence of the printing works, always with the generous and idealistic support of its shareholders. Ganymed Press continued to print until 1963 and prolonged its life under the roof of Waterlow's own collotype department for another two years until this department also came to an end.

What hastened the end of collotype in this country was the element of instability inherent in its technique, the demands of the highest sensitive craftsmanship, the attraction of high wages in large firms using standard processes, and last but not least, the process itself had become redundant, except on the very highest level, by the technical advances made by the offset process.

The great technical developments which have occurred in offset printing over recent years have produced very fine work, but none on the level of the best facsimile collotype. Ideally one would like to see a unit inside a University Press, which without the burden of large overheads could develop the screenless version of offset with a small team of craftsmen concerned only with work of the highest quality. A possible future for facsimile printing seems to lie there. Unlike other forms of pre-industrial printing, woodcuts, engraving, etching or lithography, the collotype process requires too many stages, chemical reactions difficult to control and too much equipment to be worked as a cottage industry.

The French Pochoir process — as used in the facsimile of Henry Moore's Sketchbook 1926 — uses collotype for one

or two key printings, but inserts the colours by brushing paint through stencils. This process achieves very persuasive results by the physical presence of the pigment on the paper — (as the printer of this facsimile sketchbook, Monsieur Jacomet, confessed to me 'je suis un fausseur autorisé') but it is less successful when fine gradations are required in continuous areas. Colour collotype never took hold in France.

During the years of Ganymed's printing over one hundred subjects were published. At first the editions consisted of about five hundred copies, later this was gradually increased to about a thousand. Subjects were reprinted from the existing negatives when necessary. During these years printing orders were received from outside organisations; for example The Abby Aldrich Rockefeller Folk Art Museum of Williamsburg, Virginia, sent six American primitive pictures for reproduction; illustrations were printed for a book on Worcester porcelain, as were the illustrations for a book on Bewick by Reynolds Stone. Perhaps the most interesting was the making of facsimile reproductions of forty water colours, gouaches and drawings, by the Indian poet, Rabindranath Tagore, which the Indian Government at Nehru's initiative, published for the centenary of the poet. The encounter with these originals was one of the surprises of a lifetime as the work was strikingly modern, vital and original — not at all an echo of past modes.

After the closing of the printing works Ganymed Press continued to publish; this part of the firm was taken over by the Medici Society in 1979.

Ganymed Press had already in its early stages, printed and published original graphic work. The admiration of E.C. Gregory for Henry Moore's work had led at first to the reproduction of several of Moore's drawings. Later on the artist felt tempted to use the collotype process for original graphic work. Moore thought that he could obtain special effects beyond the limits of lithography by drawing on the matt side of plastic foils, one for each colour of the intended subject and instructing the collotype printer which coloured inks should be used in the build-up of the print. This procedure was akin to colour-lithography but the plastic foils allowed the artist to use washes and lines and drawing over a spattering of wax which would not have been possible on a lithgraphic stone. After seeing a proof from the printer, the artist could make changes in the colours and adjustments in tonal range. Three subjects made by this method were published in 1951 each in a limited edition of seventy five signed copies. They were called Collographs. If there was no repetition of this method, which had fully satisfied the artist, it was due to the slow sales though the price at the time was twelve guineas each. They are now very rare and highly valued.

The next major publication of original graphic work was the Leda Suite by Sidney Nolan in 1961. Australian artists had made a great impact through exhibitions at The Tate and The Whitechapel Gallery, and Nolan was prominent amongst them.

When his paintings on the theme of 'Leda and the Swan' were shown — a departure from Australian landscapes and the folk-hero Ned Kelly— they showed a latent graphic quality and we felt that variations on the theme could be created by exploring it in a different medium. We approached the artist with a suggestion that he try his hand at lithography.

The necessary lithograph stones were purchased. These had been discarded outside the wall of Chromoworks (who had long abandoned them when they had changed to printing offset from zinc plates) and were taken to Nolan's studio. It was to be his first venture into lithography and he was at once attracted by the smooth grain and faintly yellow surface of the stone. After a few trials with lithographic chalk he started drawing and in quick succession completed some fifteen lithographs on the theme of Leda, all different in approach, in composition and in graphic treatment. Out of these the artist selected eight for publication. These eight were printed by John Watson and were published in an edition of one hundred and twenty five copies. It was an immediate success which encouraged us to set up a separate company for the publication of original graphic work, 'Ganymed Original Editions Ltd.'

The next major work planned was an edition of 'King Lear' with lithographs by Kokoschka. The idea was stimulated by the great Kokoschka exhibition at The Tate Gallery in 1962. Kokoschka's work had been buried and submerged by the Nazi movement and his paintings removed from museums. His work was little known in this country, admired by only a few who could accept and understand the strangeness and intensity of his vision. The exhibition at The Tate, displaying much of his life's work in seven galleries, was a revelation of his extraordinary power. Leaving the exhibition I reflected that Kokoschka had not done a major graphic suite since the eleven lithographs of 'Bachkantate' in 1914. As the quater-centenary of Shakespeare's birth was approaching and knowing of Kokoschka's interest in the theatre and Shakespeare in particular (he had contributed lithographs to an anthology 'Shakespeare Visionen' in 1918) I wrote to him with the suggestion of a suite of lithographs inspired by 'King Lear'. I had in mind a volume containing the whole text of the play with as many lithographs as Kokoschka felt inspired to make. He invited me to his home at Villeneuve above the Lake of Geneva where I arrived on January 13. I carried with me a detailed plan for the publication and after three hours of conversation Kokoschka exclaimed "'King Lear'— that thrills me very much — come back in three days time". At this second meeting he showed me the first lithographic drawing, Edgar as a beggar. I took the drawing to Wolfensbergers in Zurich. I had known them for a long time for the excellence of their lithographic studio, but did not realise that I revived a connection of long standing. They had exhibited Kokoschka's work in their gallery in 1923 and had printed a poster with his self-portrait which had been one of the milestones in

the development of his art. They transferred the drawing at once to the stone and proved it to Kokoschka's satisfaction. He drew fourteen further lithographs in quick succession. When we looked at the proofs at Wolfensberger's studio Kokoschka made a few corrections on the stones, a slight emphasis here, a deletion there, working without glasses though he was then in his 77th year. One essential scene was still missing in his sequence of lithographs, the very catharsis of the drama, Lear's prayer in the storm. This lithograph followed two weeks later with the most original image of Lear emerging from the ground like an earth god facing the elements — a conversion comparable to that of St. Paul.

The speed at which Kokoschka completed the lithographs inspired all the other contributors to the making of the book: Barcham Green, who supplied the hand made paper, a special making for the size, The Oxford University Press who set the text by hand in their 17th century Fell type and printed it on dampened paper in the traditional manner (they even accepted, after some hesitation, that the paper should remain untrimmed which made it difficult for them to keep the type area always in the same position), Wolfensbergers printing the lithographs, Mr. Seymour marbling the sheets for the end-papers and Wigmore Bindery binding the volumes in vellum. With the co-operation of all these firms we were able to send a completed volume to Kokoschka about ten months after the first meeting in January.

These lithographs are a profound echo to the play created in visual terms by an artist who was himself an original writer and had been a dramatist in his early days, and whose mind was deeply rooted in European literature. There is in Kokoschka's work a true relationship to Shakespeare's words which is unique in this century, as could be seen in the Arts Council exhibition 'Shakespeare and the Arts' where his 'King Lear' was shown.

The next work I discussed with Kokoschka was a suite of lithographs based on 'The Odyssey', starting with Odysseus' return to Ithaka following with the stages of recognition, the revenge on the suitors, and his re-union with Penelope. Kokoschka took to this theme with enthusiasm. This least classical of modern artists had a deep love for Greek Antiquity. Before starting on 'The Odyssey' he went to Apulia, a part of Magna Graecia where he found a landscape, people, ruins and a survival of a simple life, which struck him as homeric. After completing 'The Odyssey' suite that I had suggested, he wrote that he felt so identified with the figure of Odysseus that he now wished to cover the whole of 'The Odyssey'. A new sequence was worked out and Kokoschka finally completed forty four lithographs. This exceeded by far the limits of a book, so it was decided to contain each lithograph in a folder on which was printed the relevant passage from Robert Fitzgerald's inspired translation. The Oxford University Press printed this text in Fell type on De Wint paper from Barcham Green.

When Solander boxes were needed to contain the forty four folders and lithographs we had great difficulty in finding a bindery to undertake the work for a whole edition. The name of John Randall was recommended who, we were told, did very fine work. John Randall had never heard of Solander boxes, but though no longer young was the rare type of craftsman ready to approach new tasks. After an hour's discussion with the head of the British Museum's bindery, Randall was confident that he could do what we asked and in fact, did it to perfection, as can be seen from the Solander boxes for the 'Odyssey', for 'Saul and David' and for Moore's 'Stonehenge' and 'The Reclining Figure' among others.

After the publication of 'The Odyssey' we proposed to Kokoschka three biblical subjects from which he selected 'Saul and David' saying that it was nearest to a Shakespearean tragedy. No other narrative of the Bible was so full of close observation, profound insights into the motives of human nature, so varied in the delineation of character. The main protagonists are shown in the round, even their appearance is described in detail. It is the interplay of characters, the complexity of motives, the elemental passions which made Kokoschka call the story Shakespearean. As in his drawings for 'King Lear' and 'The Odyssey' Kokoschka is not primarily concerned with the outline of place and situation, these are incidental to him. He goes straight to the inner drama and tension of the event, the living moment and what transcends it. He is the witness of an immediate experience without the veil of historical remoteness.

This was the last of Kokoschka's great cycles that was published by Ganymed.

As already mentioned, the earliest publications of original graphic work had been the three Collographs by Henry Moore in 1951.

In 1970, having been deeply impressed by Moore's etchings of The Elephant Skull, I wrote to him:

'May we suggest a successor to the theme (Elephant Skull) based on a work of man, not as ancient as the elephant skull, but very ancient in terms of history. What we have in mind is a suite on Stonehenge. This is the most monumental relic of the Stone Age in Europe and with its use of the most ancient material, the bones of the earth so to speak, the works of sun, water and wind upon it, a witness to eternity like the skull of the primeval animal'.

While I had felt that something akin to the spirit of Stonehenge could be found in many of Moore's drawings, I was still surprised by what I heard when I saw him to discuss the suggested suite. Moore explained that Stonehenge had fascinated him since his boyhood when he had seen illustrations of it in books. When he came to London on a scholarship to the Royal College, one of the first things he did was to take a train to Salisbury and without waiting for the next morning, he went straight out to Stonehenge and saw it first in the moonlight. Since then he had visited Stonehenge twenty or thirty times. What

interested him was not so much the history of Stonehenge but what it was now, the size, the working of the stone, the effect of the weather, the sculptural grandeur. Moore fully responded to Ganymed's suggestion, producing a suite of fifteen lithographs to which a further lithograph and two etchings were added for the édition de tête.

The transfiguration of what Moore saw into his own world of forms revealed a profound sympathy, a compelling affinity with the spirit of the primeval monument. The suite moves from the almost topographical into the mysterious realm of Moore's sculptural imagination maintaining the connection with the monument.

Stephen Spender, an old friend of the artist, was asked to write an introduction, and this incorporates Moore's own response to the subject as well as Spender's reflections on the lithographs.

Moore was ready to involve himself in the publication beyond the creating of the lithographs. A full vellum binding was suggested for the Solander box, which in its texture and colour would agree with the contents, and for this Moore provided a large signature and the title written in rough hewn lettering for the front of the box. Another addition was the etching on the title page. This was based on a drawing which he cut out in a rough oval shape. After supplying him with a copper plate cut to the same shape he made the etching which was printed on the title page. All the type matter on this page and Stephen Spender's Introduction were handset in Caslon and printed by hand on his Columbia Press by Ian Mortimer.

The next suggestion to Moore was a facsimile reproduction of one of his sketchbooks. Moore chose one from 1926 which was complete and ranged widely from a quite realistically drawn dog fight, a portrait of his mother and scenes from the circus, to drawings which set down ideas for sculpture, of which four were executed. The sketchbook of 1926 witnessed a period when Moore developed into the Moore we know. It contains many written statements which show the influences he underwent at the time. Moore wrote an introduction to the catalogue under the characteristic title: "Henry Moore (in 1976) on this Sketchbook of 1926" which contains reminiscences on the life he led when this sketchbook came into being, and a statement on drawing and sculpture which defines and illuminates his attitude to their relationship then and now. A further contribution from the artist came in the form of two etchings with aquatint destined for the édition de tête, both with their origins in sketches of circus scenes in the sketchbook. The facsimile reproduction was made by Jacomet in Paris by the pochoir process, which has already been described.

Moore wrote in the Introduction to the facsimile Sketchbook 'most artists have obsessional themes, subjects which recur in their work — one such with me is the Reclining Figure'. As we wished to publish a graphic work of Moore's on the occasion of his 80th birthday, we suggested a suite

based on this theme. Moore created a retrospect on this, his favourite theme, and embedded most of the figures in a surrounding landscape. He decided this time on etching and the use of aquatint in colour for some of the eight subjects. They were printed by Lacourière et Frélaut in Paris on Richard de Bas paper — the oldest surviving paper mill on the Continent.

Stephen Spender was again asked to introduce the suite, this time in the form of a poem 'Homage to Henry Moore' into which he could weave a childhood episode which had left its mark on the artist's imagination. This poem and the other text matter were printed by Ian Mortimer from handset Caslon type. The artist wrote both his signature and the title for the cover of the Solander box. This box was bound in Richard de Bas *chiné* which has a wonderful texture both to sight and touch. The title of the work on the title page is in Bodoni Corsivo, obtained from Italy; a type-face, sinuous and severe at the same time which seems to express what it says. For the édition de tête Moore created variations on some of the etchings in the suite by individual inking which he applied to the plate himself, a technique which goes back to Rembrandt, with dramatic and surprising effect.

Ben Nicholson was approached by Ganymed for the reason most clearly stated in Herbert Read's introduction to the first suite Ganymed published, 'Architectural Suite'

 'It was inevitable that an artist so devoted to line should be drawn sooner or later to etching, and that artist being Ben Nicholson, it was inevitable that he should make something personal of the art'.

Ganymed's Chairman, Cyril Reddihough, who has been a friend of Ben Nicholson's for half a century and owns a large collection of his work, submitted to him our suggestions, namely a suite arising from his encounters with Greek and Italian architecture. What Nicholson had achieved in drawing, we felt he could translate into etching with the same firmness of line. Like the work of all graphic artists from Dürer to Picasso it was the power of drawing which made the greatness of these etchings. This first suite of ten etchings, the 'Architectural Suite' was published in 1967. His play with perspective in these etchings surprise, disconcert and are convincing and cogent in the end like dissonances in Stravinsky's music.

This suite was followed by another called 'Greek and Turkish Forms' also of ten etchings, which took its main inspiration from travels in those countries. A third suite followed in 1971, an anthology of work both abstract and architectural, under the title 'Ben Nicholson 3'.

An artist of a very different nature whom we persuaded to try his hand at graphic work was L. S. Lowry. Ganymed Press had been the first to publish a reproduction of one of his paintings in 1955. Other reproductions followed and this contact led Lowry to visit Ganymed whenever he came to London. This strange and lonely man, who felt himself to be in

foreign parts on the rare occasions that he came south, established a close relationship with us. His provincial seclusion was part of his artistic strength. He had discovered the hidden poetry in the grey streets in the grey towns of the industrial north. When he spoke of Francis Terrace in Salford one felt it had been a numinous experience to him. During the years 1966 to 1972 he drew for Ganymed sixteen lithographs which constitute all his original graphic work. They range from his vision of northern towns to the grotesque figures which expressed his view of common humanity.

The Australian artists as we have said before, burst on the London scene in the fifties. Their originality was partly due to the impact of their own environment and the isolation caused by the war during their formative years, but to a far greater extent to an abundance of talent. Out of the great number of painters who appeared in these exhibitions, we were most impressed by Arthur Boyd, Sidney Nolan and Brett Whiteley. The origins of Nolan's 'Leda Suite' have already been mentioned. Arthur Boyd's work seemed to have an affinity with European Expressionism, which he had never directly encountered. His paintings showed his gift as a natural painter, but he also possessed a complete mastery over graphic processes. Ganymed published a number of single prints by him, one of which, a lithograph of St. Jerome, seemed to be conceived in the spirit of Altdorfer. As he had shown his instinct for dramatic composition in his sets for the Electra ballet at Covent

Garden and in etchings which followed these designs, we were encouraged to suggest to him a suite of etchings based on Aristophanes' 'Lysistrata'. After discussing a scenario and points like format, technique — aquatint and etching — he went to work on the subject which so obviously inspired him. Two months later he had a display of forty proofs on the wall of his studio — a staggering exhibition of dramatic invention and brilliant technique, completely original and at an antipodean distance from such famous predecessors as Beardsley and Picasso. The etchings were printed by Mr. McQueen at Thomas Ross's, a firm which has been established since 1833.

The youngest of the Australian artists published by Ganymed was Brett Whiteley. We had seen a large apparently abstract triptych in which torsos and limbs seemed to struggle to come out into being. Brett Whiteley was then only twenty-two years old — a year later he had a successful one-man show and we suggested that he might try his hand at graphic work. He had just left abstraction behind him and has never returned to it. This was in 1962. Fifteen years later when he came to London to prepare an exhibition, we suggested a suite of lithographs of nudes, which would coincide with his desire to move into sculpture. He made eight large lithographic drawings in different techniques, chalk and brush, which we published under the title 'Towards Sculpture'.

One part of Ganymed's activities was advice, design and supervision for other

publishers, most of it for Marlborough
Fine Art Ltd., for whom we designed
bindings and text matter for Moore's
'Reflections on the Human Effigy',
Kokoschka's 'Apulia', 'Jerusalem Faces'
and 'Women of Troy' and for Sutherland's
'Sketchbook' and 'The Bestiary'. We also
supervised the production of collotype
posters issued by the Boston Museum of
Fine Arts for their centenary.

Ganymed worked from a *bottega oscura*
in a passage off Lincoln's Inn Fields,
which enabled us to keep our overheads
low and concentrate our resources on the
highest quality.

The delight of being close to the creative
sources, of working with outstanding
craftsmen, of having the trust and co-
operation of great artists, this has been our
finest reward.

BERNHARD BAER

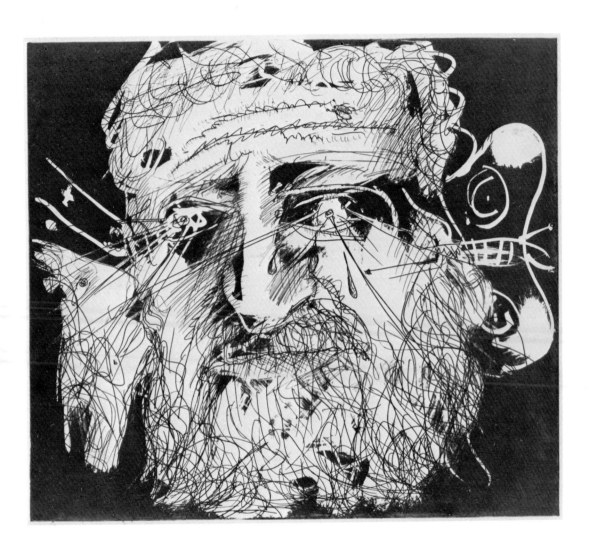

Plate I

This judgment of the heavens, that makes us tremble,
Touches us not with pity. O, is this he?
The time will not allow the compliment
Which very manners urges.
Kent I am come
To bid my king and master aye good night.
Is he not here?
Albany Great thing of us forgot!
Speak, Edmund; where's the king? and where's Cordelia?
 [*the bodies of Goneril and Regan are brought in*
See'st thou this object, Kent?
Kent Alack, why thus?
Edmund Yet Edmund was beloved:
The one the other poisoned for my sake,
And after slew herself.
Albany Even so. Cover their faces.
Edmund I pant for life. Some good I mean to do,
Despite of mine own nature. Quickly send
(Be brief in it) to th' castle, for my writ
Is on the life of Lear and on Cordelia.
Nay, send in time!
Albany Run, run, O run!
Edgar To who, my lord?—[*To Edmund*] Who has the office? Send
Thy token of reprieve.
Edmund Well thought on. Take my sword,
Give it to the captain.
Albany Haste thee, for thy life!
 [*Edgar hurries forth*
Edmund He hath commission from thy wife and me
To hang Cordelia in the prison and
To lay the blame upon her own despair,
That she fordid herself.
Albany The gods defend her!
Bear him hence awhile. [*Edmund is borne off*

106

Plate II

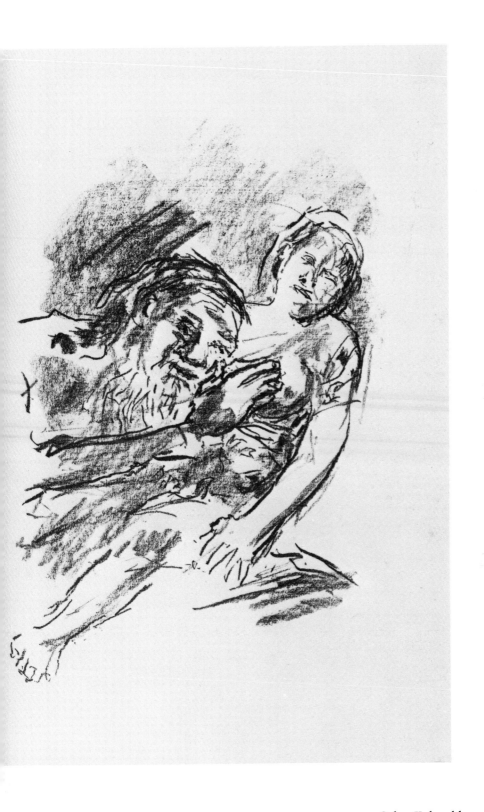

Oskar Kokoschka
"King Lear with Cordelia in his arms" and facing page
Lithograph 1963

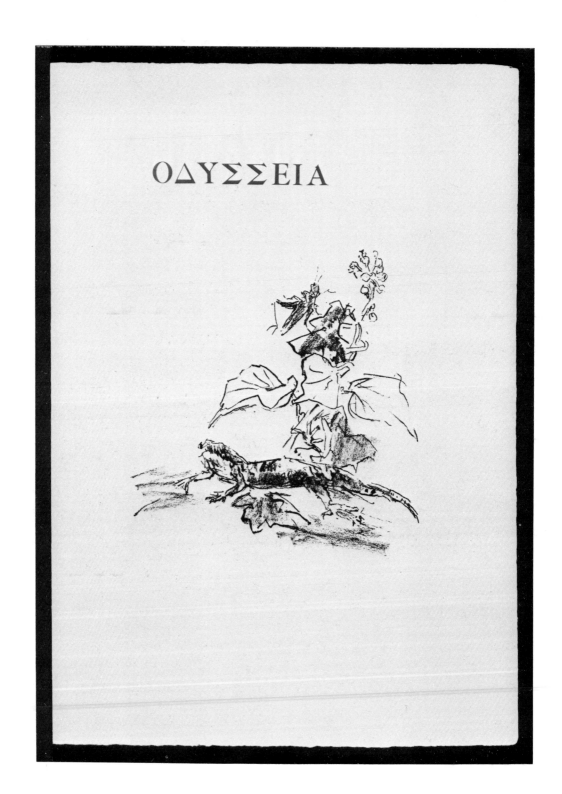

ΟΔΥΣΣΕΙΑ

Plate III

Oskar Kokoschka
"The Odyssey", frontispiece
Lithograph 1965

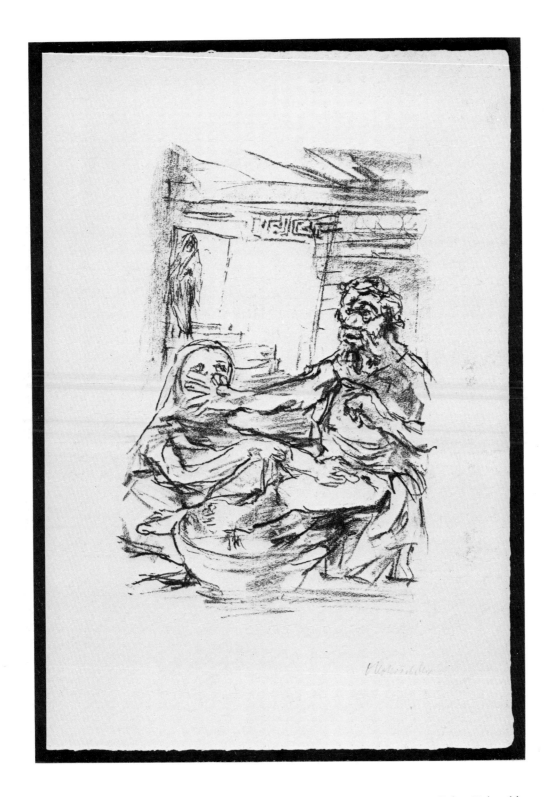

Oskar Kokoschka
"Eurykleia recognises Odysseus" from The Odyssey
Lithograph 1965

Plate IV

KOKOSCHKA
Saul and David

שאול ודוד

Oskar Kokoschka
"Saul and David", title-page
1969

Plate V

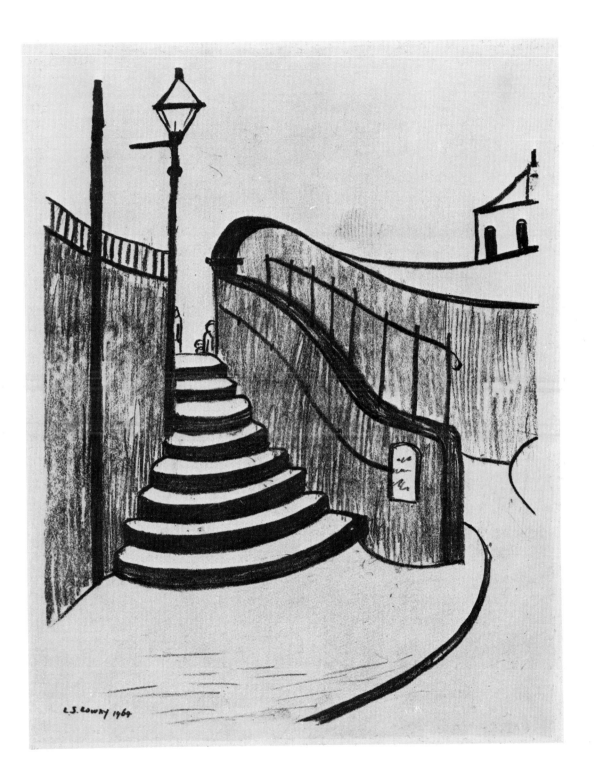

Plate VI

L S Lowry
"Old Steps, Stockport"
Lithograph 1969

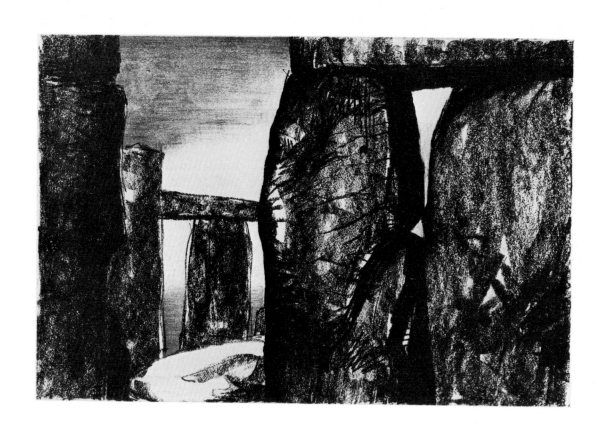

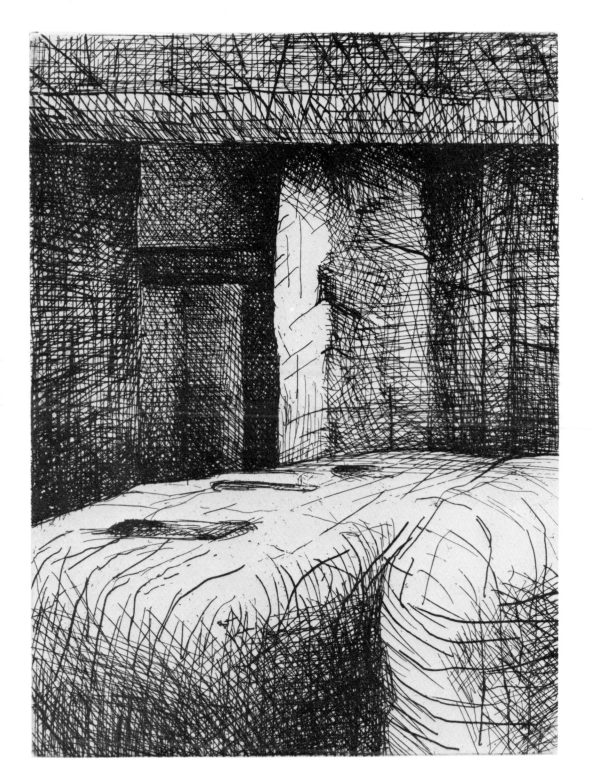

Henry Moore
"Stone with lintel sockets" from Stonehenge
Etching 1973

Plate VIII

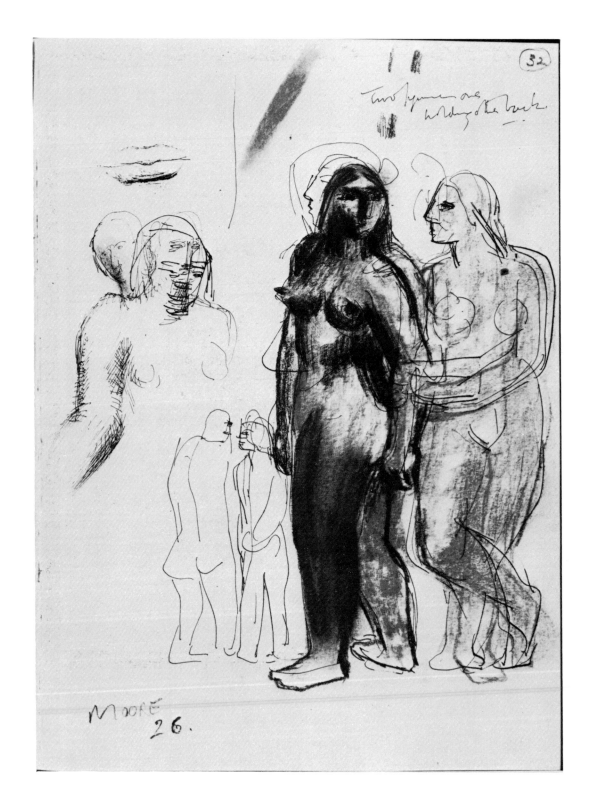

Henry Moore
"Sketchbook 1926", page 32
1976

Plate IX

HENRY MOORE

the reclining figure

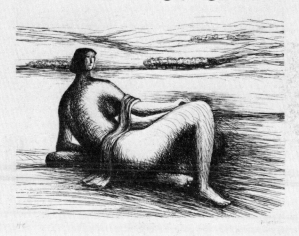

GANYMED

Plate X

Henry Moore
"The Reclining Figure", title-page
Etching 1978

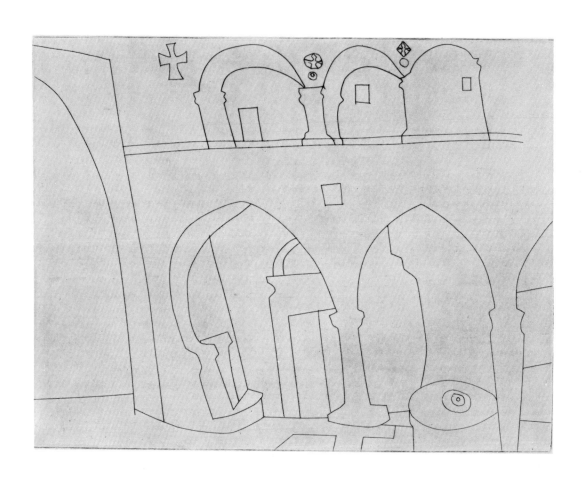

Ben Nicholson
"Patmos Monastery" from Greek and Turkish Forms
Etching 1968

Plate XI

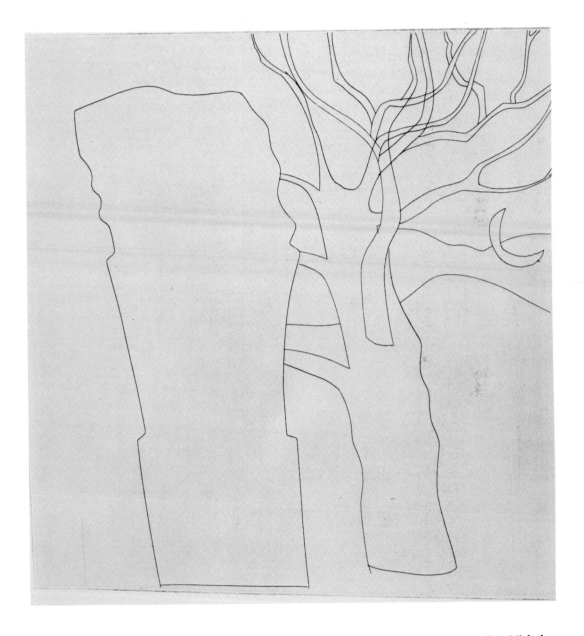

Ben Nicholson
"Tree, Column and Moon" from Ben Nicholson 3
Etching 1971

Plate XII

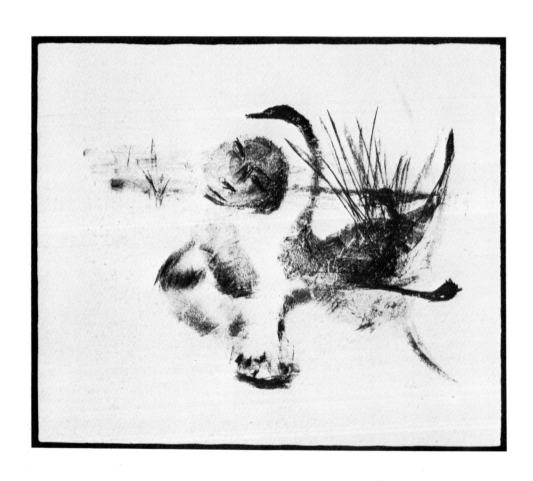

Sidney Nolan
"The Leda Suite", No 2
Lithograph 1961

Plate XIII

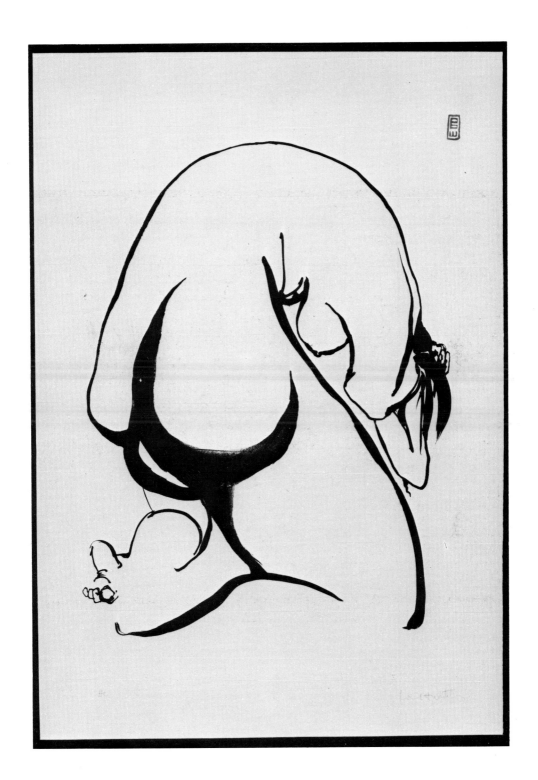

Brett Whiteley
"Towards Sculpture", No 6
Lithograph 1977

Plate XIV

Arthur Boyd
"Lysistrata". Solander box.
Hide with vellum inlay and drawing and lettering by the artist

Plate XV

Catalogue

Original Graphic Work

BOYD, Arthur (b.1920)

Lysistrata. 1970.
This suite was inspired by Aristophanes' comedy about
the women who occupy the Acropolis and refuse to
surrender until the men of Athens and Sparta end the war.
The standard suite of fifty sets consists of twenty etchings.
There are ten additional etchings in the édition de tête of
twelve sets. Each etching is 35 × 40 cms. and all are
numbered and signed by the artist. The etchings were
printed by hand under the supervision of the artist by Mr.
McQueen of Thomas Ross & Co. London on handmade
paper made by Barcham Green Ltd.
The hide Solander box with vellum inlay was made by
F. & J. Randall Ltd. London. *(see Plate XV)*

Ganymed Original Editions Ltd.

1. No. 6. "Old men enter carrying fagots to smoke out the women". *E.1474–1979*

2. No. 14. Lysistrata:
"They are all deserting. The first I caught was sidling
through the postern close by the cave of Pan". *E.1482–1979*

3. No. 16. "Myrrhine and Kinesias"
Lysistrata:
"You know how to work. Play with him, lead him on". *E.1484–1979*

Plate I **4.** No. 20. Chorus:
"Invoke with a shout
Dionysos out of whose eyes
Breaks fire on the Maenads that follow". *E.1488–1979*

5. **Jinker on a Sandbank.** 1978. *On loan*
45 × 61 cms.
Edition: one hundred copies, numbered and signed by the
artist.
An original lithograph printed in six colours by the
Curwen Studio, London, on Saunders mould made paper.

Ganymed Original Editions Ltd.

BOYD, Arthur

6. **St. Jerome.** 1971. *E.490–1972*
56 × 42 cms.
Edition: seventy five copies, numbered and signed by the
artist.
Original lithograph printed in four colours by J. E.
Wolfensberger of Zurich.

Ganymed Original Editions Ltd.

KOKOSCHKA, Oskar (1886–1980)

King Lear. 1963.
A limited edition of two hundred and seventy five signed
and numbered copies of Shakespeare's "King Lear". Page
size 45.5 × 35.5 cms. The work contains sixteen
lithographs by Kokoschka. The lithographs were printed
from the stone by J. E. Wolfensberger of Zurich. The text
was set by hand in Fell type and printed on handmade
paper at the University Press, Oxford, by Vivian Ridler,
Printer to the University. The paper was specially made
for this edition by Barcham Green Ltd.
The binding is by Wigmore Bindery, London.

Ganymed Original Editions Ltd.

7. Frontispiece and Title-page. *R.C.K.27.*

8. No. 3. Edmund.
Act I Scene II. "This is the excellent foppery of the *On loan*
world".

9. No. 7. Lear in the storm. *On loan*
Act III Scene IV. "Poor naked wretches".

Plate II **10.** No. 15. Lear with Cordelia in his arms. *On loan*
Act V Scene III. "If that her breath will mist or stain the
stone, why, then she lives".

KOKOSCHKA, Oskar

The Odyssey. 1965.
A suite of forty four lithographs.
Edition: standard edition fifty sets, édition de tête nine sets.
The lithographs were numbered and signed by the artist. Sheet size 57 × 39.5 cms. They were printed from the stone by J. E. Wolfensberger of Zurich. Each lithograph is contained in a folder with a quotation of the relevant passage of the text in the translation of Robert Fitzgerald. The text was set by hand in Fell type and printed at the University Press, Oxford, by Vivian Ridler, Printer to the University.
The handmade paper was made by Barcham Green Ltd. The leather covered Solander box, made by F & J Randall Ltd. London, has a device designed by the artist on the front cover.

Ganymed Original Editions Ltd. and Marlborough Fine Art Ltd.

	11.	The original drawing for the design on the Solander box.	*On loan*
	12.	The Solander box covered in leather, blocked in gold with vellum titles on the spine. 61.5 × 45.5 × 12 cms.	*On loan*
Plate III	13.	Frontispiece. Lithograph by Kokoschka signed on the inside. Greek title set in Fell type by Oxford University Press.	*L. 2697–1980*
	14.	No. 6. Odysseus shipwrecked. Book V lines 314–333.	*On loan*
	15.	No. 7. Odysseus meets Nausikaa. Book VI lines 125–149.	*On loan*
Plate IV	16.	No. 34. Eurykleia recognises Odysseus. Book XIX lines 464–489.	*On loan*

KOKOSCHKA, Oskar

Saul and David. 1969.
A suite of forty one lithographs, numbered and signed by the artist.
Édition de tête six sets, standard edition sixty sets.
Each lithograph measures 42.5 × 32.5 cms. and is contained in a folder with the relevant extract from the Old Testament in the Authorised Version of the Bible.
The lithographs were printed from the stone by J. E. Wolfensberger of Zurich.
The letterpress was printed in Baskerville by Curwen Press Ltd, London.
The handmade paper was made by Barcham Green Ltd.
The Solander box in full hide with vellum inset for the édition de tête and in full hide for the standard edition was made by F. & J. Randall Ltd. London.

Ganymed Original Editions Ltd. and Marlborough Fine Art (London) Ltd.

	17.	Solander box in full hide with vellum inset. 49.5 × 40 × 8.5 cms.	*On loan*
	18.	The original drawing by Kokoschka for the title-page and for the Solander box. 37 × 52 cms.	*On loan*
Plate V	19.	Title-page	*L.2697–1980*
	20.	No. 4. The Spirit of God came upon Saul. 1 Samuel 11.1–7.	*On loan*
	21.	No. 26 David dancing before the Ark. 2 Samuel 6.12–19.	*On loan*
	22.	No. 30. The letter to Uriah. 2 Samuel 11.6–17.	*On loan*
	23.	No. 39. David in his old age. 1 Kings 1.1–4.	*On loan*

KOKOSCHKA, Oskar

Jerusalem Faces. 1973.
This suite of six lithographs was created by the artist
during his visit to Jerusalem in April, 1973. It was
published on behalf of the Jerusalem Foundation by
Marlborough Fine Art (London) Ltd. and Weidenfeld &
Nicholson Ltd.

*The Solander box and text matter were designed by
Ganymed.*

24. The Solander box, covered in hide with a vellum spine and *L.2697–1980*
vellum insets with gold blocking, was made by Legatoria
Artistica, Ascona. The lettering was drawn by Ilan Hagari.
71.5 × 54.5 × 3.8 cms.

LOWRY, Laurence Stephen (1887–1976)

Lithographs. 1972.
Fourteen lithographs were published between 1967 and
1972. The editions were limited to seventy five copies,
numbered and signed by the artist. They were printed
from the stone by J. E. Wolfensberger of Zurich.

Ganymed Original Editions Ltd.

Plate VI **25.** No. 9. "Old Steps, Stockport". *E.24–1980*
62 × 48 cms.

26. No. 12. "Francis Terrace, Salford". *E.27–1980*
48 × 61.5 cms.

MOORE, Henry, OM, CH (b.1898)

Three Collographs. 1951.
Edition: Seventy five copies of each, numbered and signed by the artist.
Printed by Ganymed Press from the original drawings on transparent foils for each colour on handmade paper from Arnold and Foster.

27. "Figures in setting". (G. Cramer, Henry Moore, Catalogue of Graphic Work, No. 5.)
43 × 61 cms.

On loan

Colour frontispiece

28. "Standing figures". (Cramer, No. 9.)
37.5 × 46 cms.

Dept. of Prints and Drawings.

29. "Woman holding cat". (Cramer, No. 10.)
37.5 × 50.5 cms.

Dept. of Prints and Drawings.

Ganymed Press London Ltd.

Stonehenge. 1973.
The standard edition consisting of sixty sets, contains fifteen lithographs and one etching on the title page. The édition de tête consisting of twenty five sets, contains in addition to the fifteen lithographs, one lithograph (A) and two etchings (B and C). All are numbered and signed by the artist. The suite is introduced with an essay by Stephen Spender.
The lithographs 1 to 15 were printed by J. E. Wolfensberger of Zurich; the additional lithograph A by Curwen Studio, London; the two etchings B and C by Lacourière et Frélaut, Paris; the etching on the title-page by M. Basis, London.
The text was set and printed on his handpress by Ian Mortimer, London.

MOORE, Henry, OM, CH

The paper for the lithographs and the title and text pages was made by Barcham Green Ltd.
The paper for etchings B and C was made by Richard de Bas.

Ganymed Original Editions Ltd.

30.	The Solander box in full vellum, with lettering designed by the artist, made by F. & J. Randall Ltd. London. 64.5 × 49.9 × 4.7 cms.	*E.463–1975*
31.	The original design by Moore for the binding.	*On loan*
32.	Moore's drawing which preceded his etching for the title-page.	*On loan*
33.	The title-page with etching signed by the artist. (Cramer, No. 207.) 21.5 × 30 cms.	*E.443–1975*
Plate VII **34.**	No. 4. "Inside the Circle". (Cramer, No. 211.) 29 × 43.7 cms.	*E.447–1975*
35.	No. 6. "Fallen Giant". (Cramer, No. 213.) 29.3 × 45.8 cms.	*E.449–1975*
36.	No. 9. "Head of a Giant". (Cramer, No. 216.) 41.5 × 29.2 cms.	*E.452–1975*
37.	No. 13. "Arm and Body". (Cramer, No. 220.) 29 × 45.5 cms.	*E.456–1975*
38.	No. 15. "Dark Cavern". (Cramer, No. 222.) 28.7 × 45.8 cms.	*E458–1975*
39.	A. "Sarsens of the inner circle and the Hele Stone". (Cramer, No. 223.) 17.4 × 25 cms.	*E.459–1975*
Plate VIII **40.**	B. "Stone with lintel sockets". (Cramer, No. 202.) 25.4 × 19 cms.	*E.460–1975*

MOORE, Henry, OM, CH

Plate IX **41.** **Sketchbook 1926.** 1976. *L.2847–1979*

A facsimile of Henry Moore's sketchbook. Page size 22 ×
17 cms, eighty five pages. The edition was three hundred
and twenty five copies, numbered and signed by the artist.
He created two etchings with aquatint for the édition de
tête, "Circus Scenes" and "High Wire Walkers".
The sketchbook was reproduced by Daniel Jacomet &
Cie, Paris by the pochoir process.
The two etchings for the édition de tête were printed by
M. Basis, London.
The handmade paper for the etchings was made by
Barcham Green Ltd.
A catalogue, which accompanied the sketchbook, was
printed by the John Roberts Press, London.
Each set was contained in a Solander box made by
Bernard Duval, Paris.

*The production was designed and supervised by Ganymed Original Editions
Ltd. Published in association with Fischer Fine Art Ltd.*
The sketchbook is shown open at pages 31 and 32.

The Reclining Figure. 1978.
The suite contains eight etchings and one etching on the
title-page. All the etchings are numbered and signed by
the artist.
Edition: sixty five sets. Sheet size 51.5 × 44.6 cms.
Stephen Spender wrote the poem "Sculptor and Statues"
to introduce the suite.
The eight etchings in the suite were printed on the
handpresses of Lacourière et Frélaut, Paris, on Richard de
Bas, Auvergne à la main. The etching on the title-page
was printed by M. Basis, London.
The text was set by hand and printed on his hand press by
Ian Mortimer, London.

*Published by Ganymed Original Editions Ltd. in association with the Louisiana
Museum of Modern Art, Humlebaek, Denmark.*

MOORE, Henry OM, CH

42. "Sculptor and Statues". Poem written by Stephen Spender *L.2540–1980*
to introduce the suite as homage to the artist on the
occasion of his 80th birthday.
Text set by hand and printed on his hand press by Ian
Mortimer, London.

Plate X **43.** Title-page with etching signed by Moore. *L.2540–1980*

44. No. 1. Etching and one aquatint plate. *Dept. of Prints and Drawings.*

45. No. 2. Etching and three colour aquatint plates. *Dept. of Prints and Drawings.*

46. No. 5. Etching. *Dept. of Prints and Drawings.*

47. No. 8. Etching and two colour aquatint plates. *Dept. of Prints and Drawings.*

48. The Solander box was made by F. & J. Randall, Ltd. *L.2540–1980*
London. It has a vellum spine, the boards are covered
with Richard de Bas handmade paper *chiné*. The lettering
on the cover is by the artist.
57.4 × 48.5 × 3.5 cms.

49. The original script by Henry Moore for the Solander box. *On loan*

NICHOLSON, Ben, OM (b.1894)

Architectural suite. 1966.
Most of the ten etchings in this suite are inspired by
Italian or Greek architecture. The suite is introduced by
Herbert Read.
Edition: standard edition forty sets, édition de tête ten
sets.
All the etchings are numbered and signed by the artist.
The etchings were printed under the supervision of the
artist by F. Lafranca, Locarno.
The Solander boxes were made by F. & J. Randall Ltd.,
London: those for the first ten sets were covered in full
hide, the remaining forty in canvas. The design on the
cover is based on the artist's drawing "couple of forms
1965".

Ganymed Original Editions Ltd. and Marlborough Fine Art Ltd.

50. No. 1. "Olympic fragment". *Circ. 580–1967*
20 × 24.5 cms.

51. No. 2. "Aquileia". *Circ. 582–1967*
32 × 27.8 cms.

Greek and Turkish Forms. 1968.
This suite of ten etchings, numbered and signed by the
artist was inspired by Nicholson's travels in Greece and
Asia Minor.
Edition: standard edition forty sets, édition de tête ten
sets.
The etchings were printed by F. Lafranca, Locarno, under
the artist's supervision.
The Solander boxes were made by F. & J. Randall, Ltd.,
London. The first ten sets were covered in full hide, the
remaining forty sets in canvas.

Ganymed Original Editions Ltd. and Marlborough Fine Art (London) Ltd.

52. No. 4. "Turkish Sundial and Column". *Circ. 233–1969*
33.2 × 22.5 cms.

NICHOLSON, Ben, OM

53.	No. 9. "Turkish Forms with Leaf".	*Circ. 238–1969*	
	32 × 27.5 cms.		

Plate XI **54.** No. 10. "Patmos Monastery". *Circ. 239–1969*
34.5 × 45 cms.

Ben Nicholson 3. 1971.
This suite is of ten etchings numbered and signed by the artist.
Edition: standard edition forty four sets, édition de tête six sets.
The etchings were printed under the artist's supervision by F. Lafranca, Locarno.
The Solander boxes were made by F. & J. Randall Ltd., London. The first six sets were bound in full hide, the remaining forty four in canvas.

Ganymed Original Editions Ltd. and Marlborough Graphics.

55. No. 3. "Lucca, small version". *Circ. 726–1971*
18 × 22 cms.

56. No. 7. "Paros Tree". *Circ. 730–1971*
24.5 × 41 cms.

Plate XII **57.** No. 10. "Tree Column and Moon". *Circ. 733–1971*
44.8 × 44.4 cms.

NOLAN, Sidney (b.1917)

The Leda Suite. 1961.
A suite of eight lithographs drawn on the stone.
Edition: one hundred and twenty five copies, numbered
and signed by the artist. The lithographs were printed by
John Watson on Crisbrook Waterleaf paper made by
Barcham Green Ltd.

Ganymed Press London Ltd.

Plate XIII **58.**	No. 2. 40.5 × 57.5 cms.		*E.41–1980*
59.	No. 7. 40 × 54.5 cms.		*E.46–1980*

WHITELEY, Brett (b.1939)

Towards Sculpture. 1977.
Whiteley created this suite of eight lithographs of the nude
during his stay in London in 1977.
The edition consists of fifty sets, all the lithographs are
numbered and signed by the artist.
The lithographs were printed by Curwen Studio, London,
on Arches Velin.
The portfolio, with the lettering drawn by the artist, was
made by F. & J. Randall Ltd. London.

Ganymed Original Editions Ltd.

60.	No. 3. 91.4 × 63.5 cms.		*E.33–1980*
Plate XIV **61.**	No. 6. 91.4 × 63.5 cms.		*E.36–1980*

Facsimile Reproductions

CÉZANNE, Paul (1839-1906)

62. **Still life with chair, bottle and apples.** 1902–06.
A Ganymed facsimile of the original watercolour in The
Courtauld Institute Gallery, London.
45 × 59.5 cms.

E.59–1980

COTMAN, John Sell (1782–1842)

63. **Dieppe Harbour.** 1823.
A Ganymed facsimile of the original watercolour in The
Victoria and Albert Museum.
30 × 52 cms.

E.55–1980

DUNOYER DE SEGONZAC, André (1884–1974)

64. **La Route de Grimaud.** 1937.
A Ganymed facsimile of the original pen and watercolour
in The Tate Gallery.
49 × 71 cms.

E.66–1980

GIRTIN, Thomas (1775–1802)

65. **A Rainbow over the Exe.** 1800.
A Ganymed facsimile of the original watercolour in The
Huntington Library and Art Gallery, California.
29 × 50 cms.

E.53–1980

MOORE, Henry, OM, CH (b.1898)

66. **Pink and green Sleepers.** 1941.
A Ganymed facsimile of the original drawing with
watercolour in The Tate Gallery.
38 × 56 cms.

E.48–1980

PALMER, Samuel (1805–1881)

67. **The Bright Cloud.** Circa. 1829 *E.54–1980*
 A Ganymed facsimile of the original pen and ink wash
 drawing in The Tate Gallery.
 25 × 30 cms.

RODIN, Auguste (1840–1917)

68. **Study.** 1913 *E.52–1980*
 A Ganymed facsimile of the original drawing in the Musée
 Rodin, Paris.
 31 × 19.7 cms.

STEER, Philip Wilson (1860–1942)

69. **Misty Morning on the Severn – Bridgnorth.** 1925. *E.56–1980*
 A Ganymed facsimile of the original watercolour.
 22 × 34 cms.

SUTHERLAND, Graham, OM (1903–1980)

70. **Sun setting between Hills.** 1937. *E.57–1980*
 A Ganymed facsimile of the original watercolour in the
 collection of Lord Clark.
 25 × 35.5 cms.

TAGORE, Sir Rabindranath (1861–1941)

71. **Half veiled woman.** *E.65–1980*
 A Ganymed facsimile of the original watercolour.
 Published in 1961 by the Government of India on the
 centenary of the artist's birth.
 64.5 × 41.2 cms.